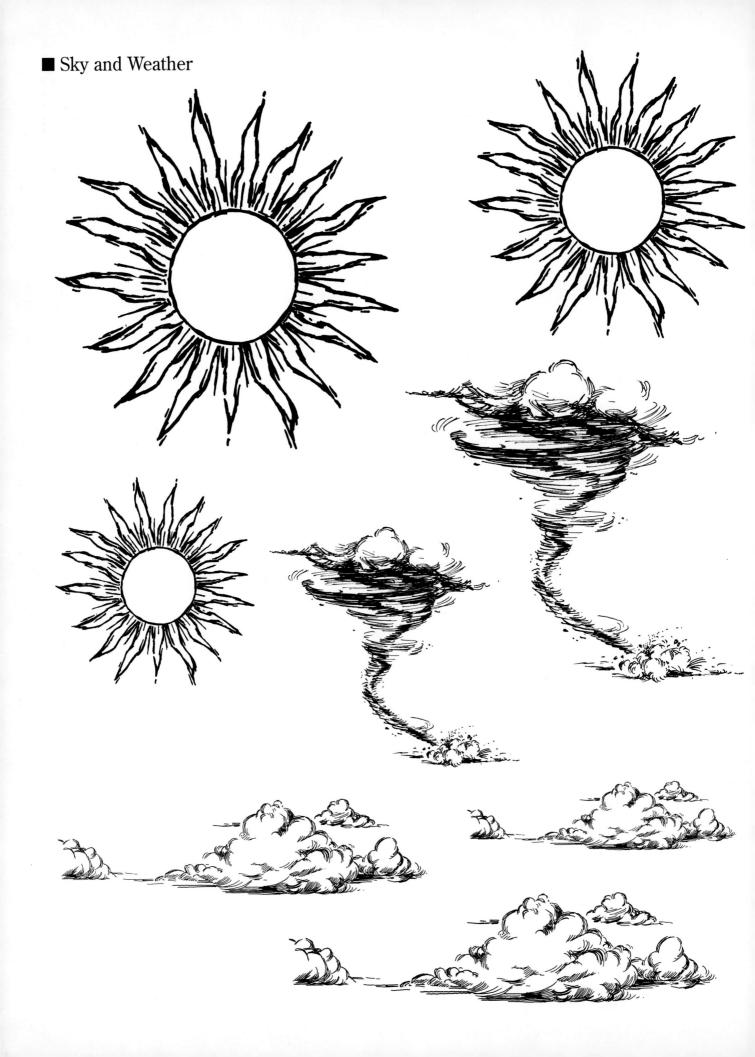

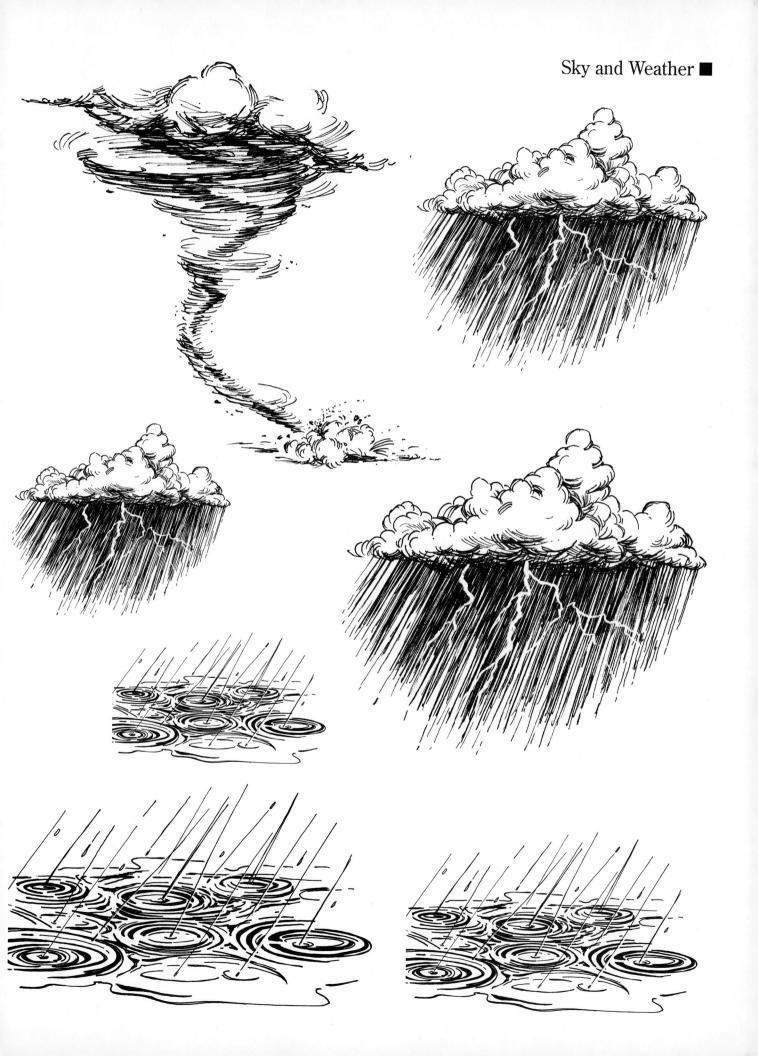

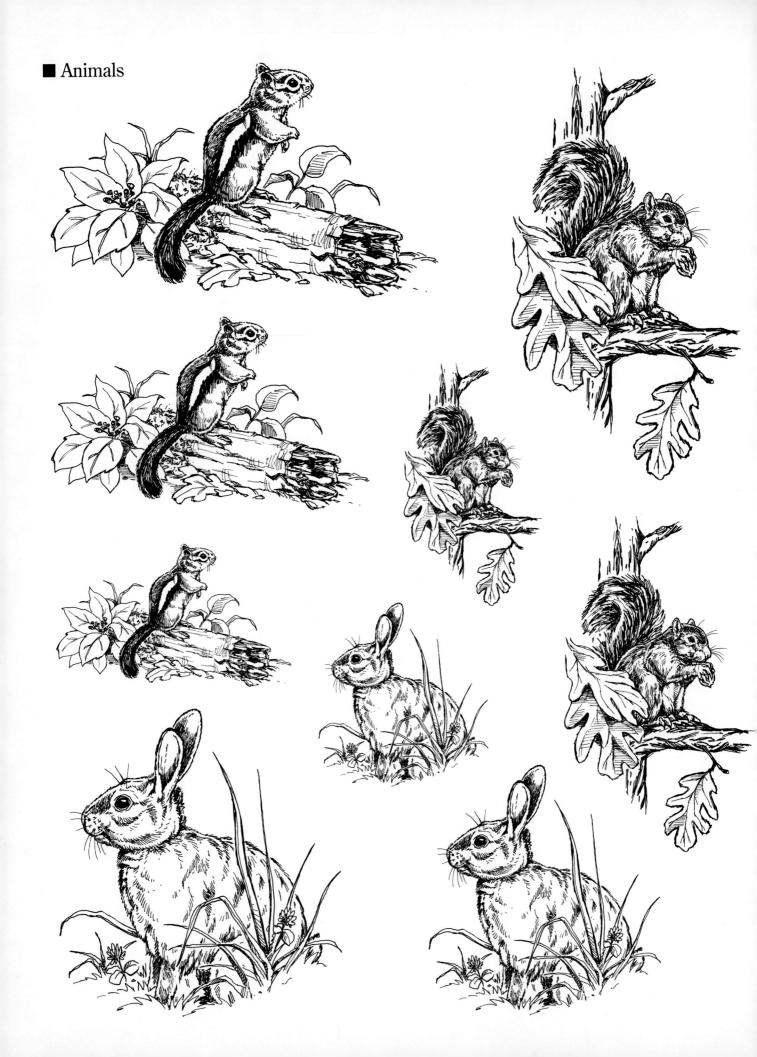

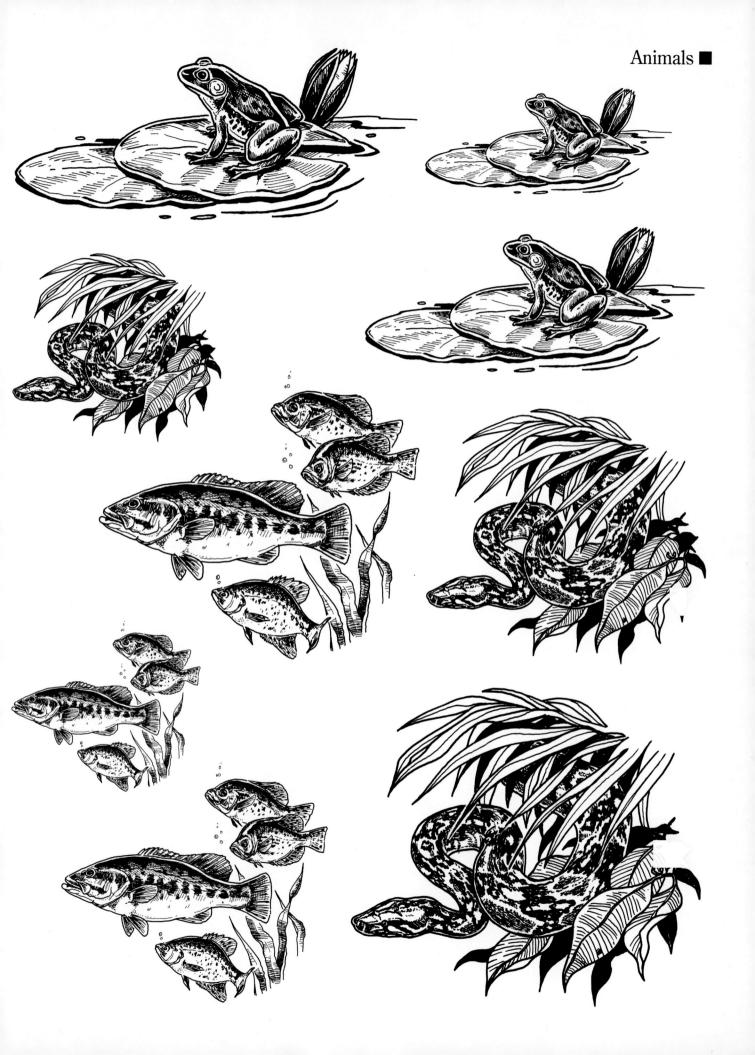

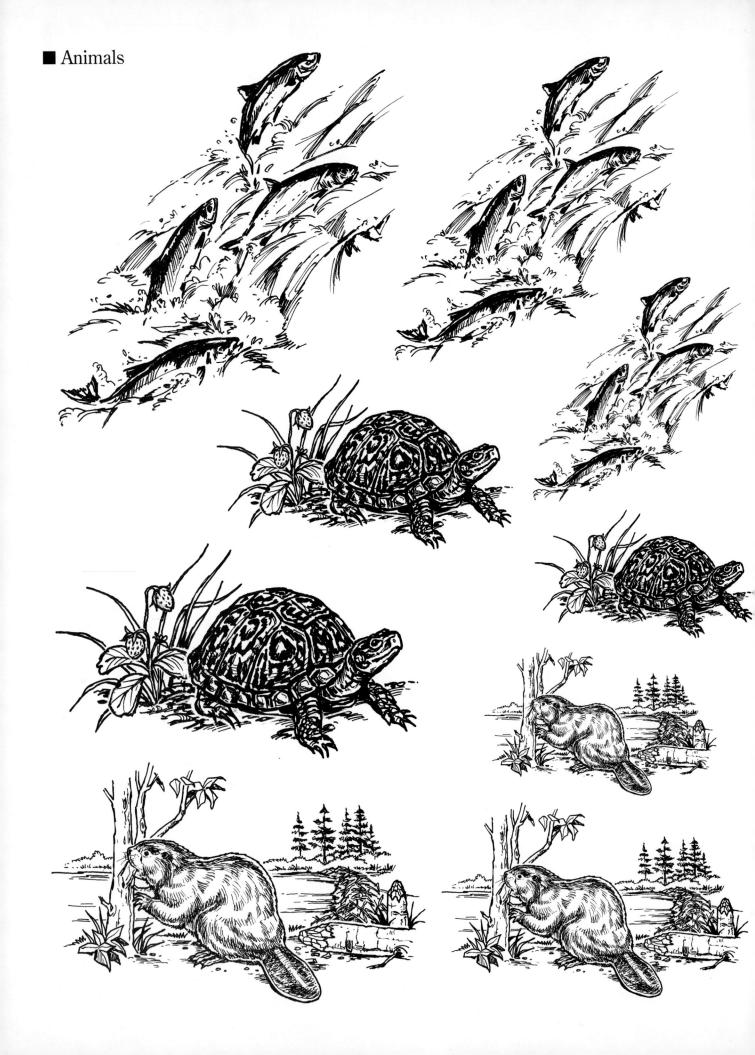

Animals

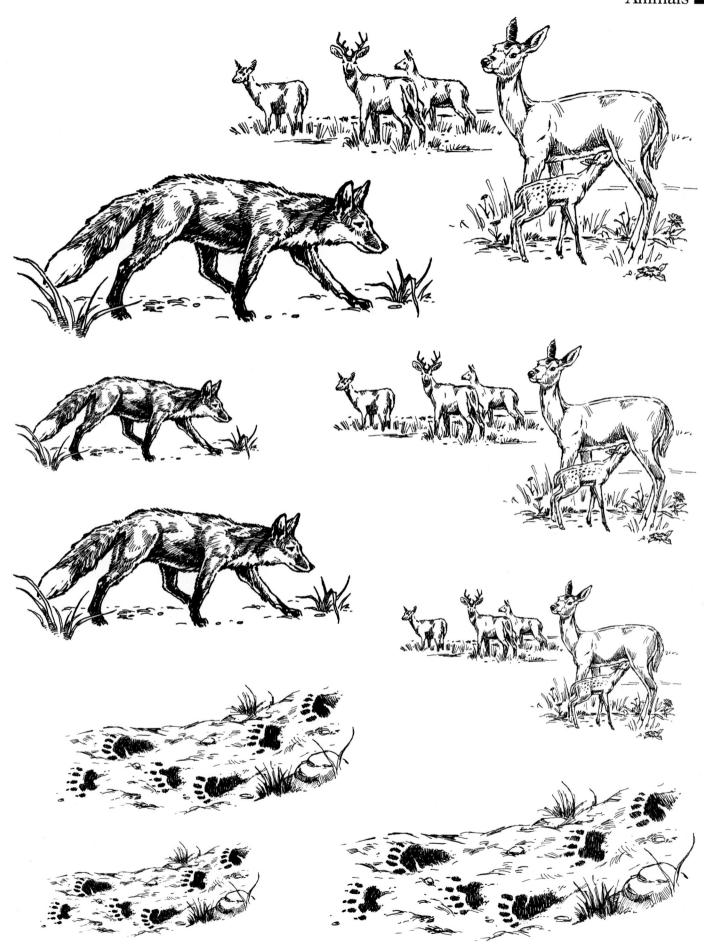

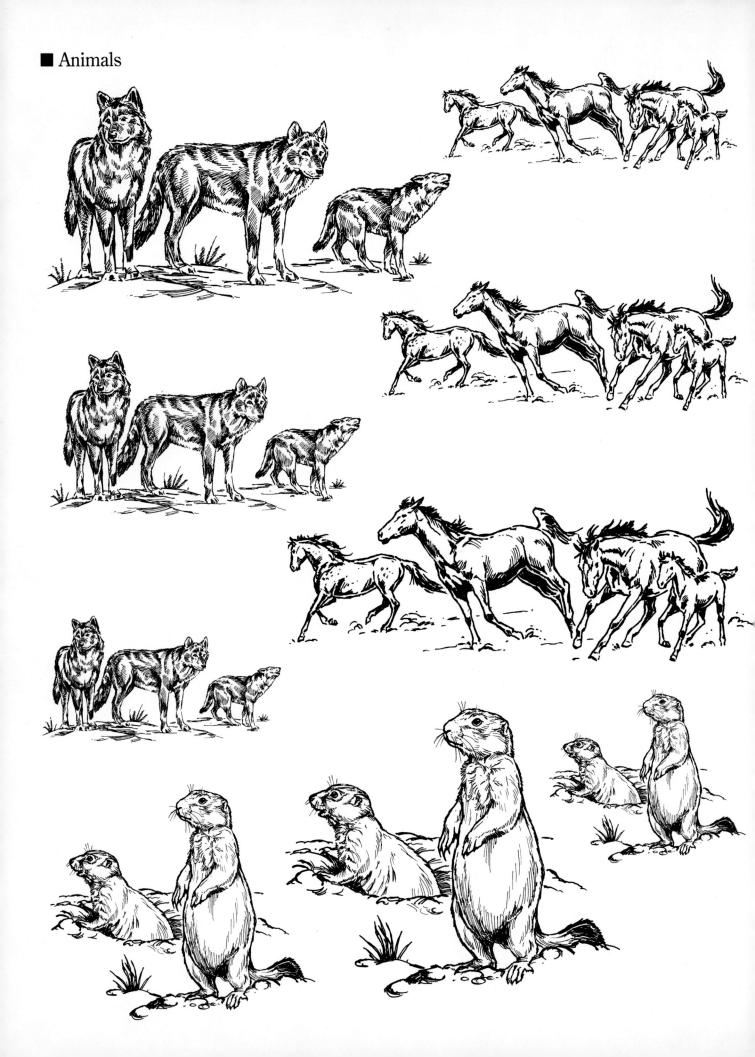

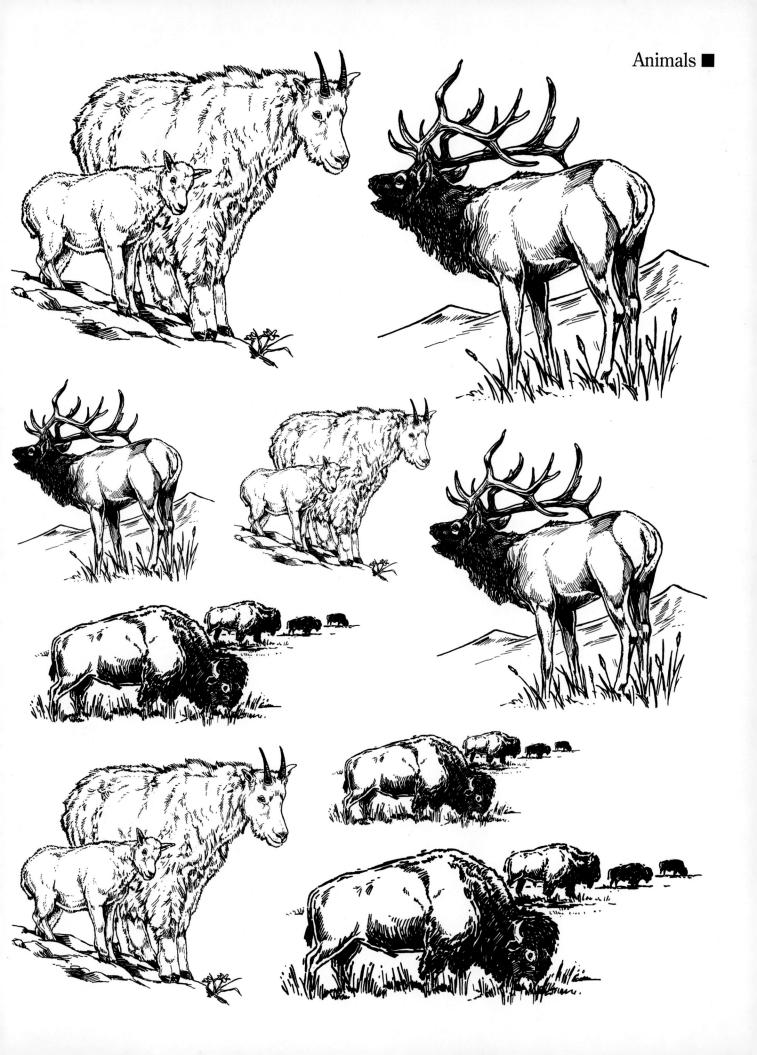

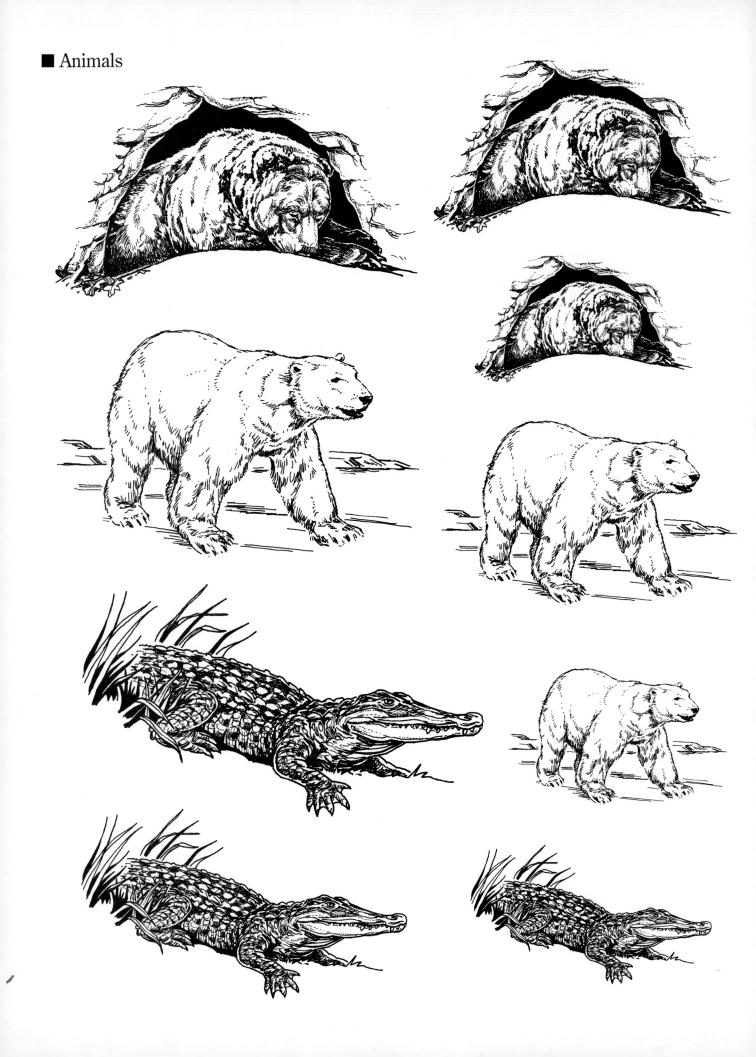

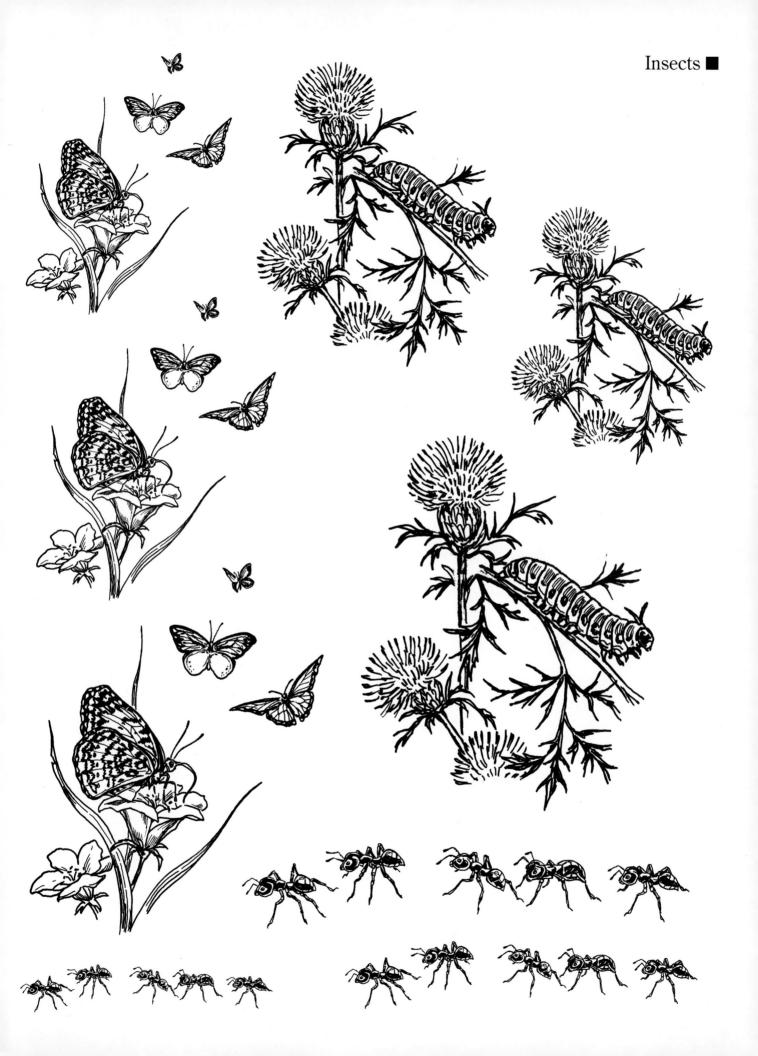

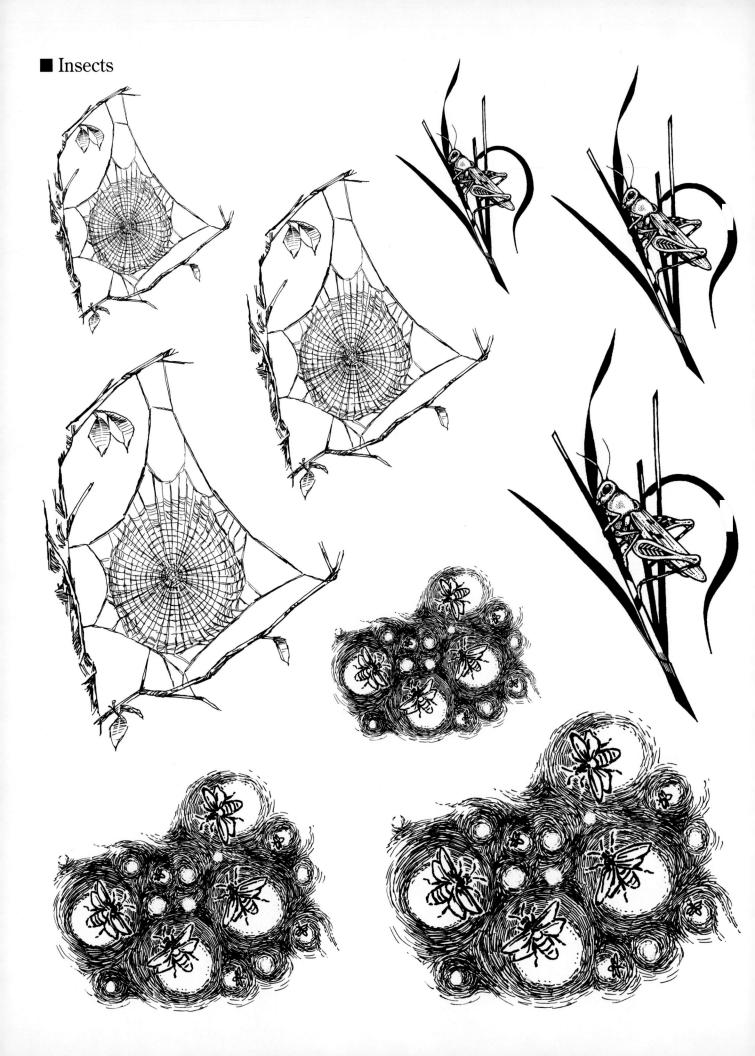

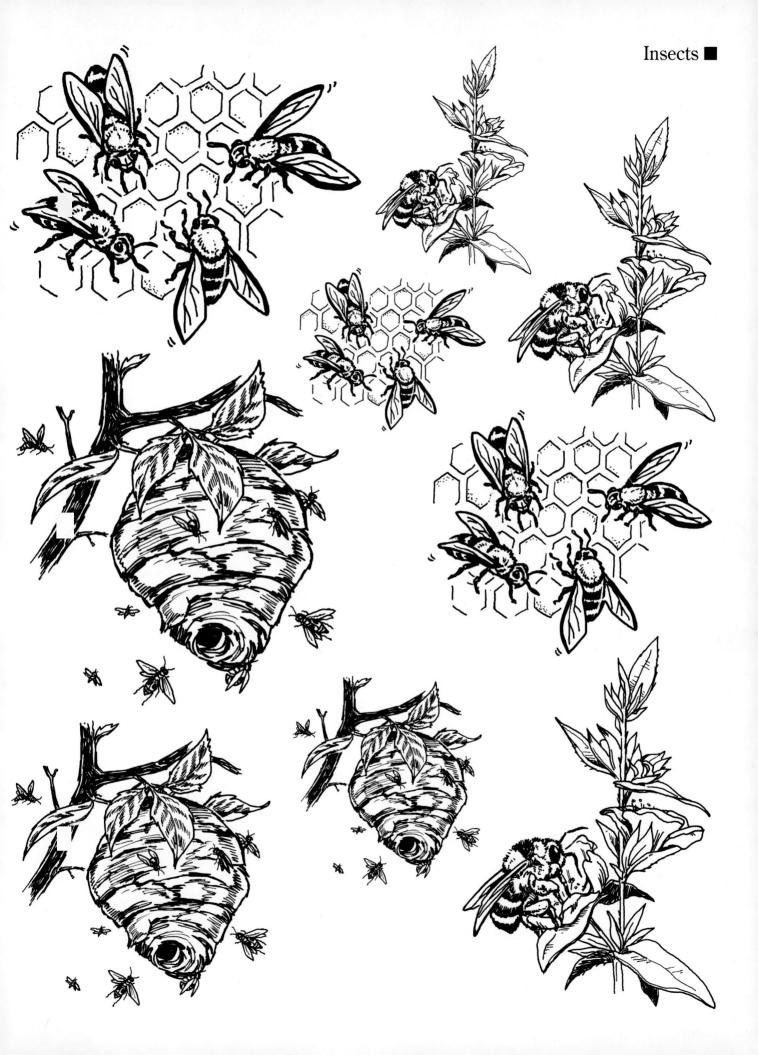

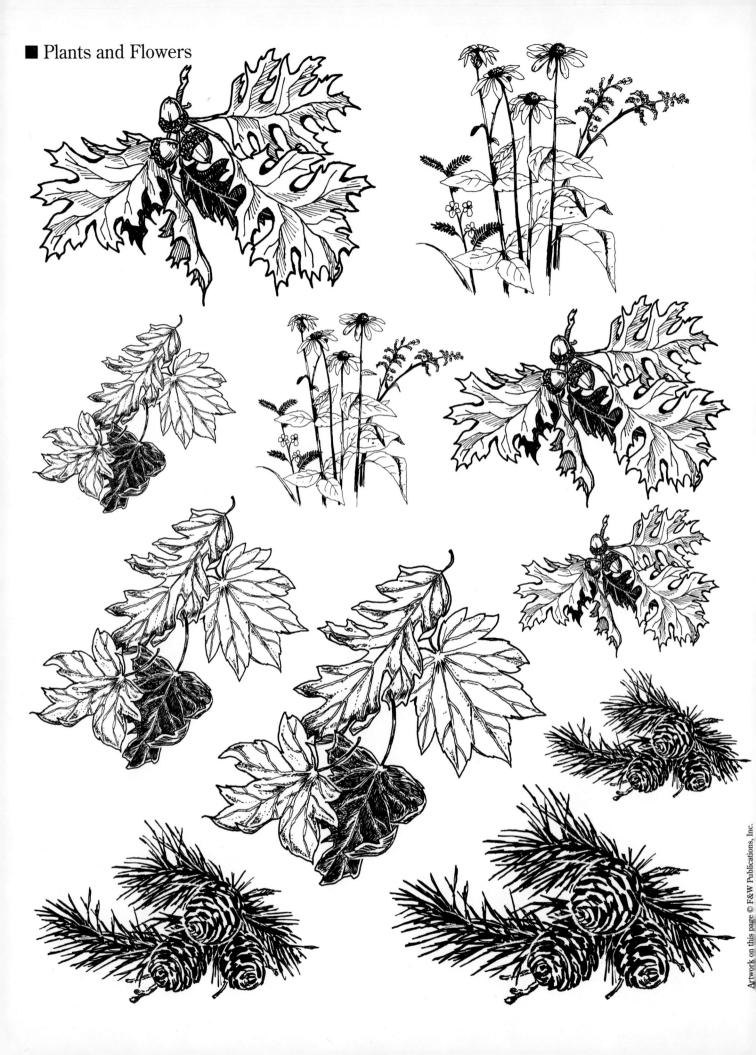

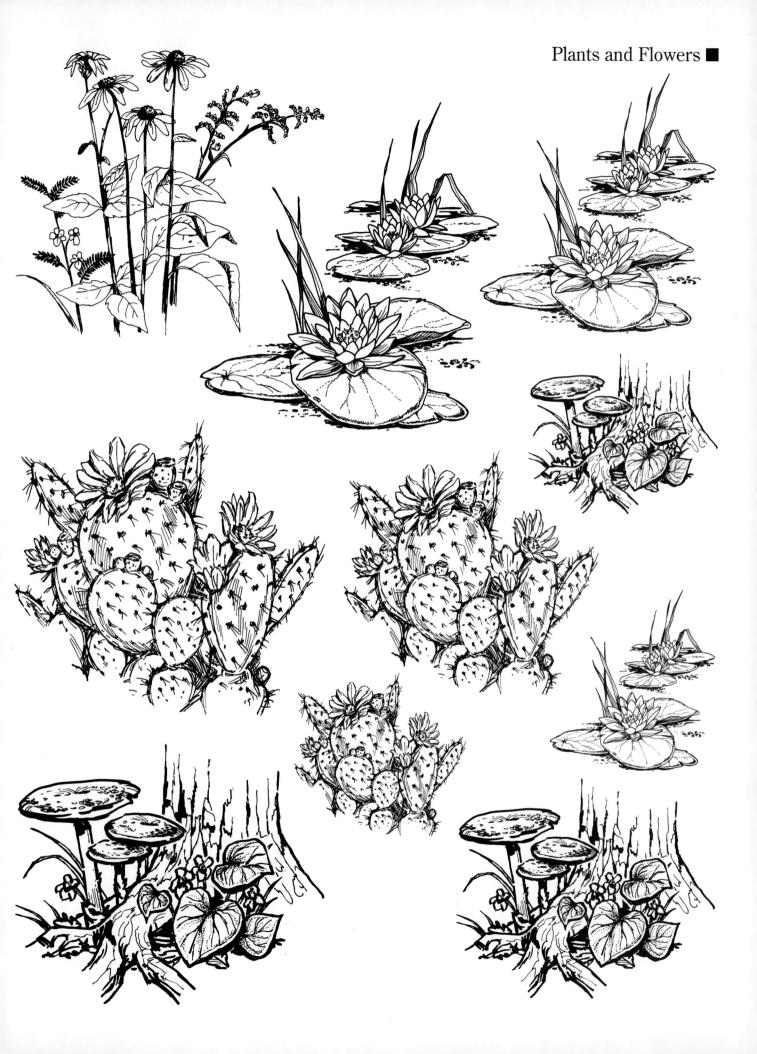

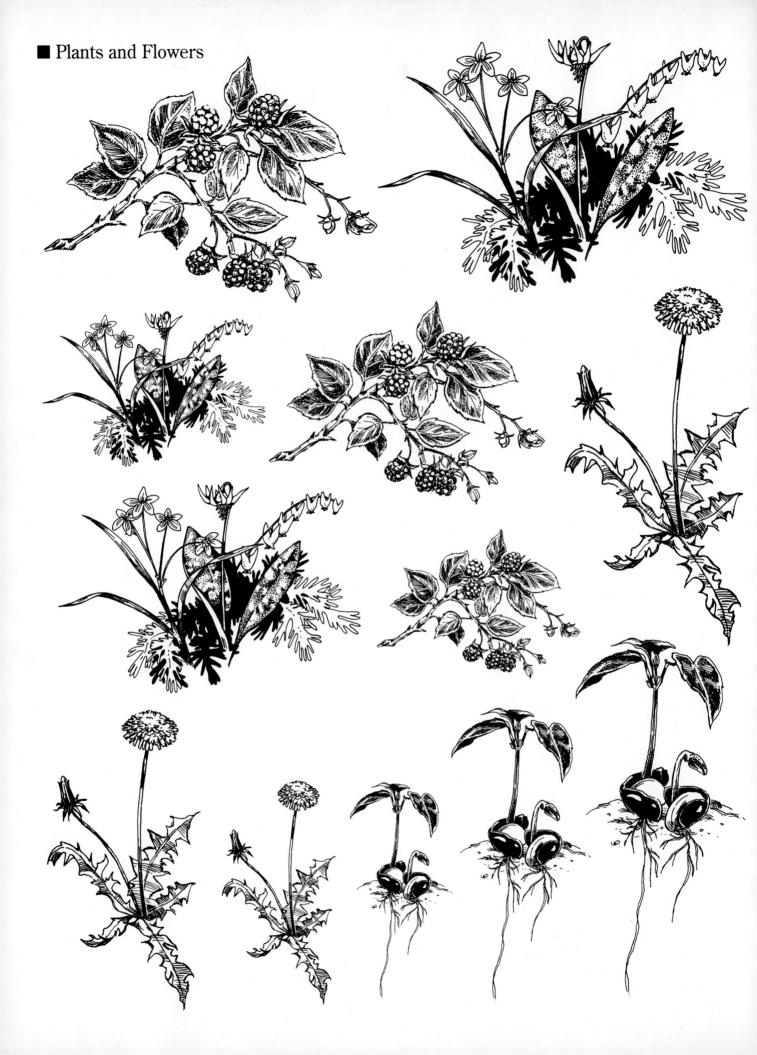

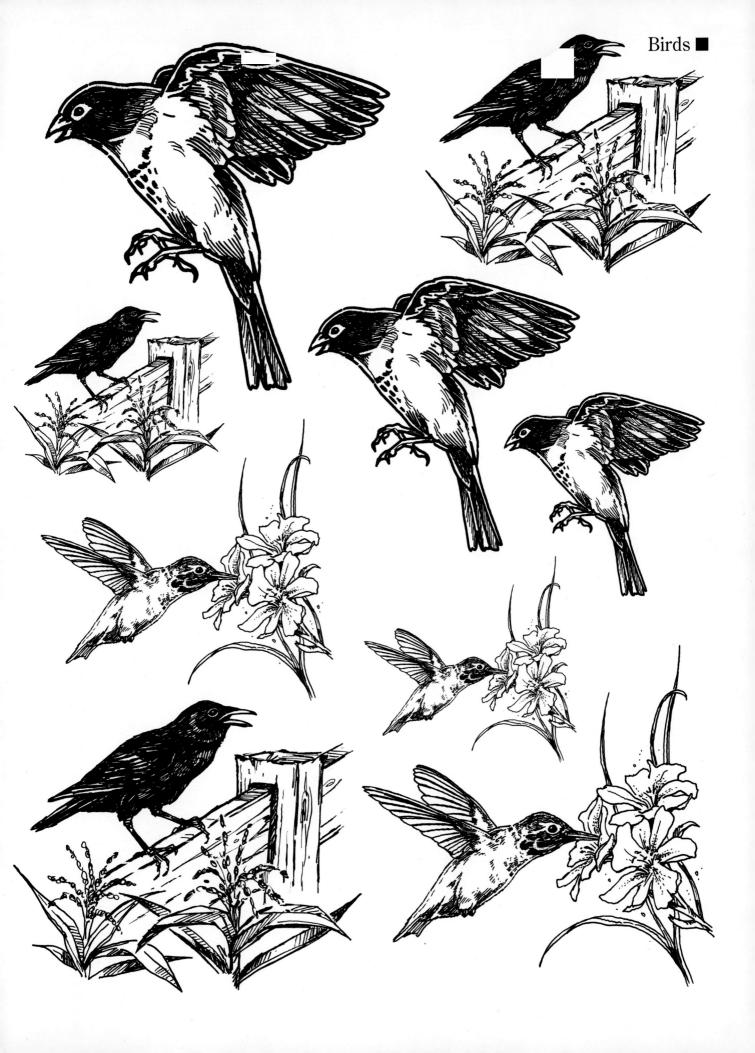

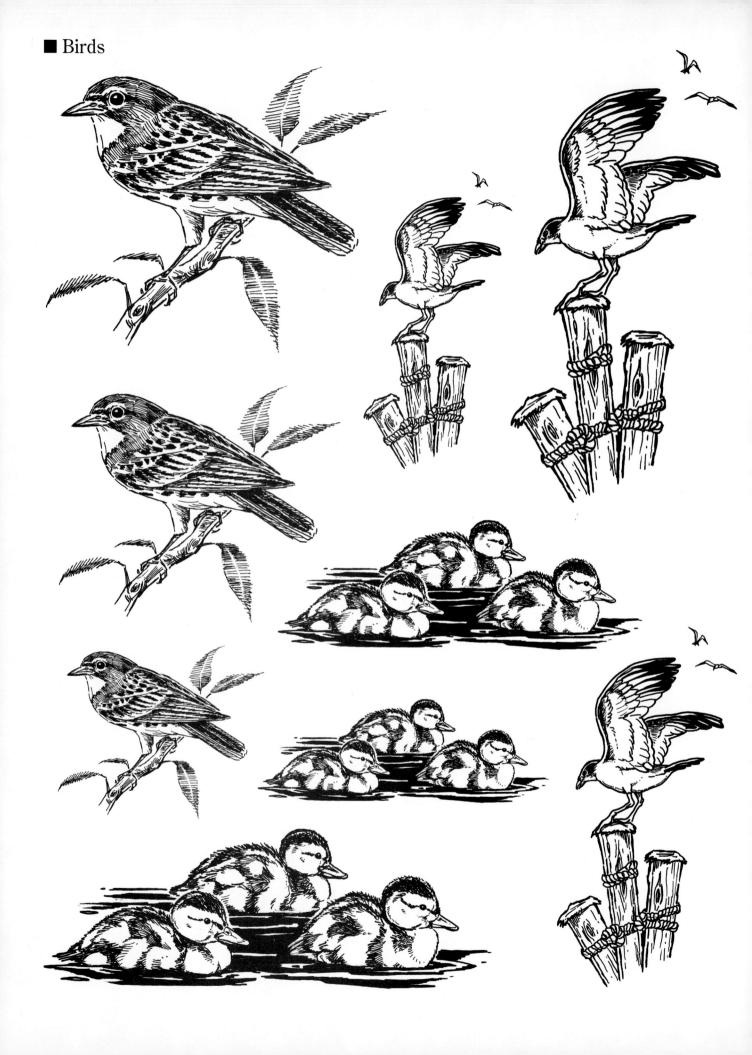

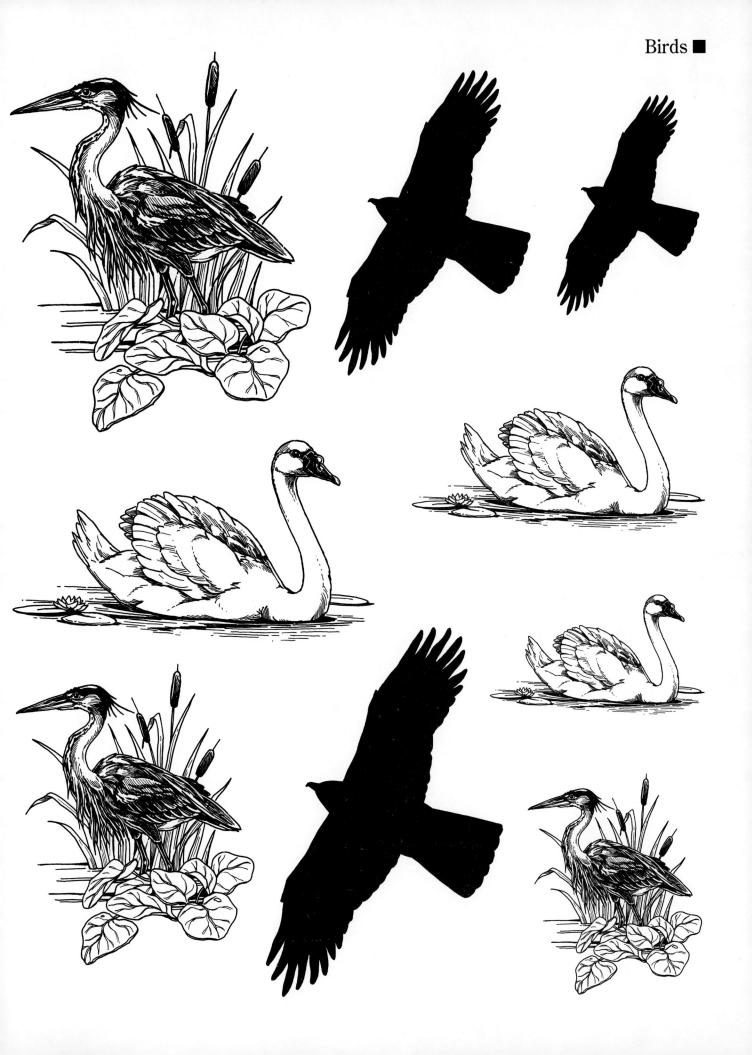

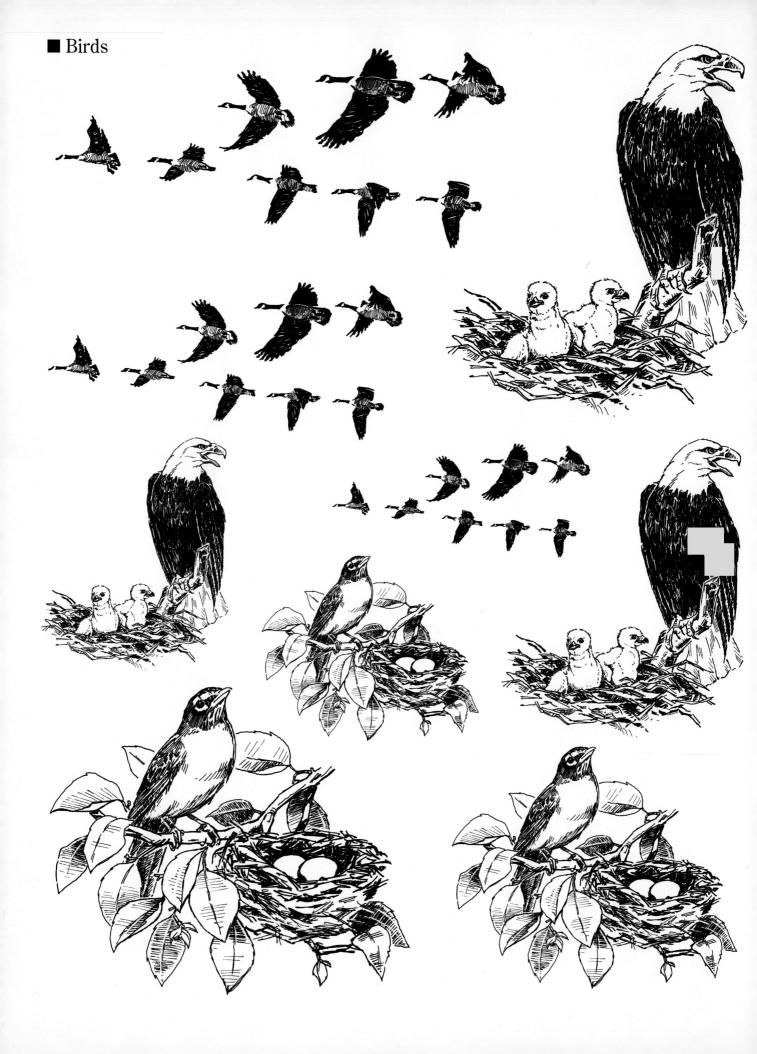

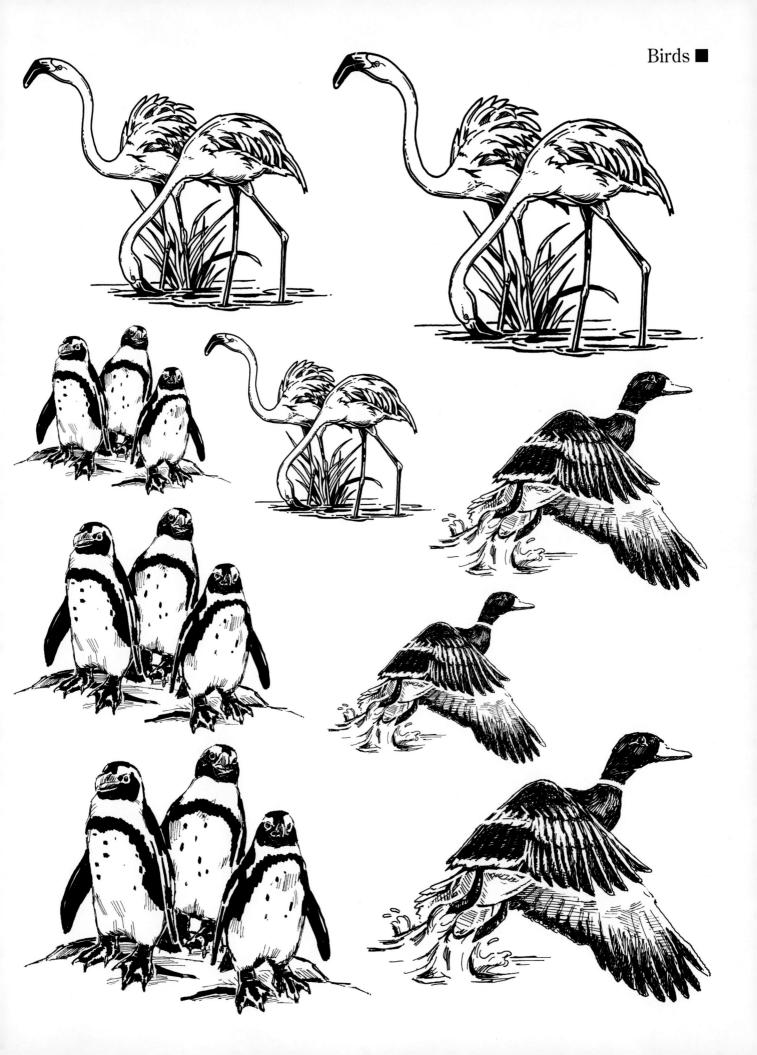

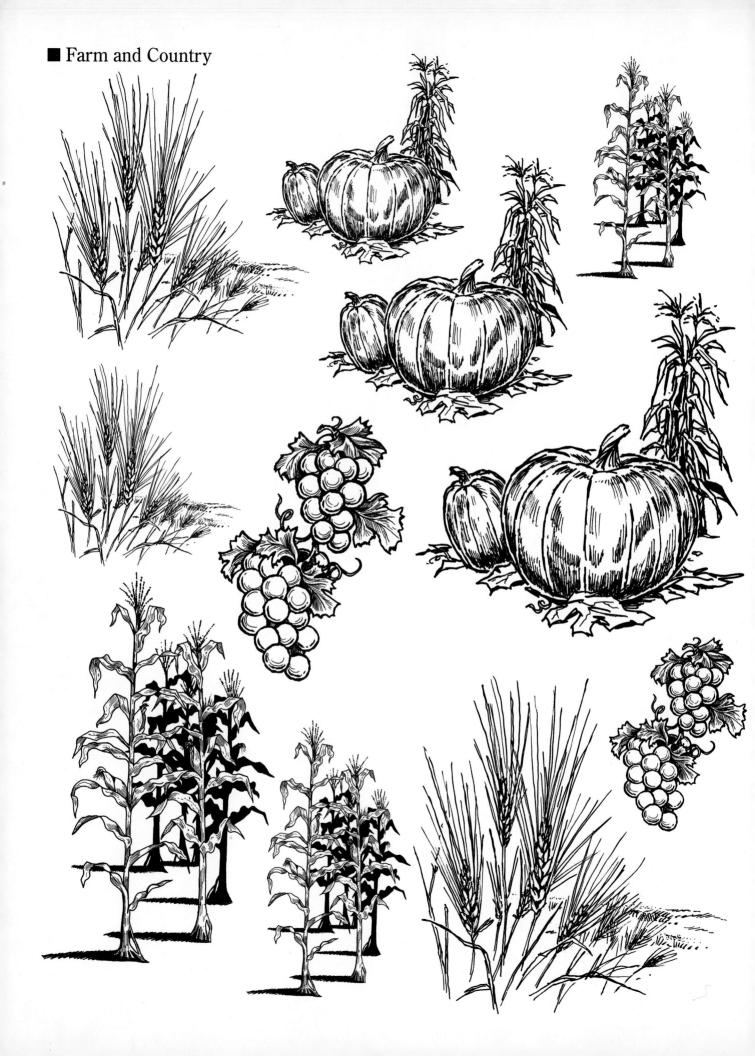

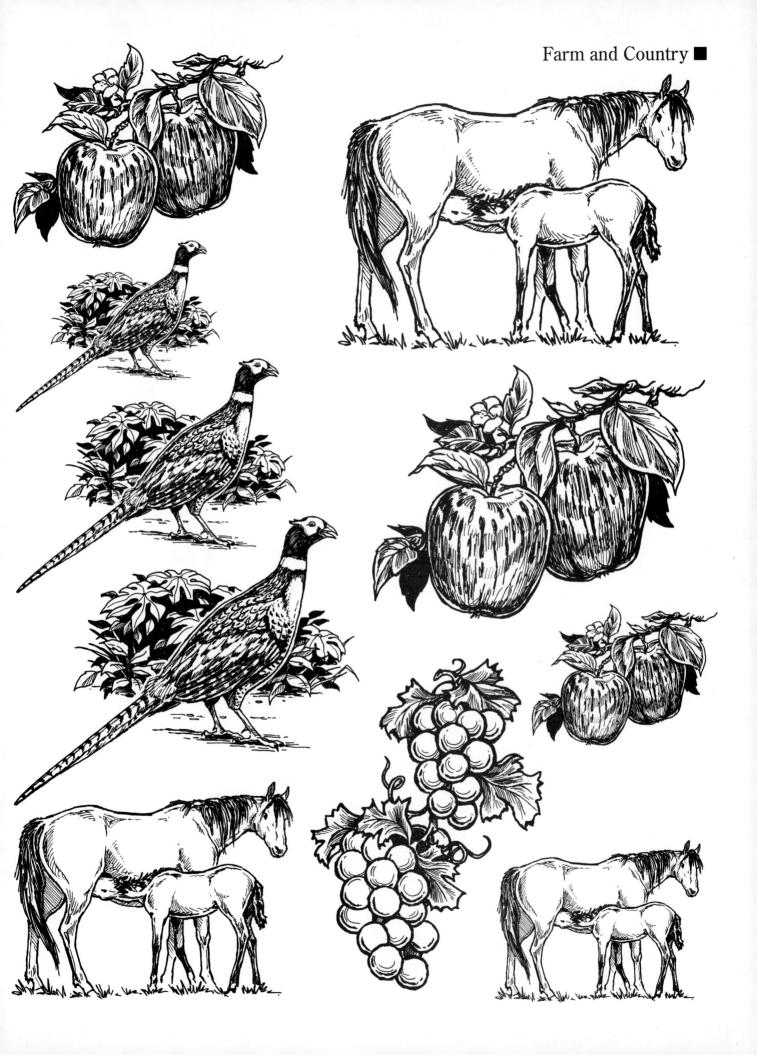

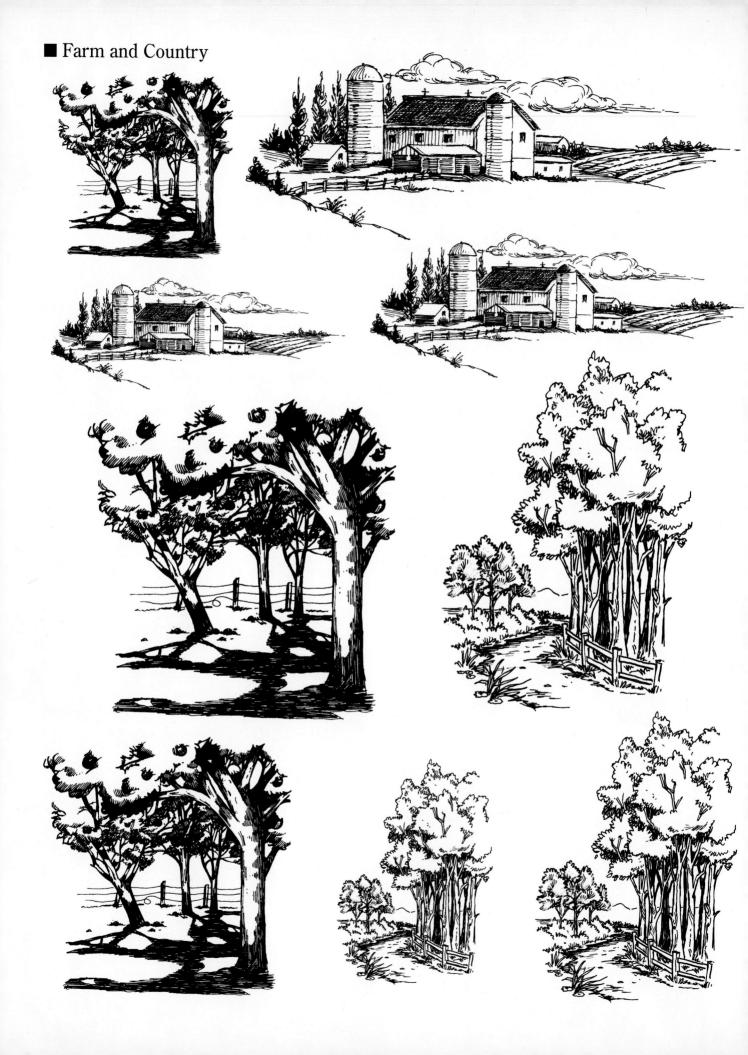

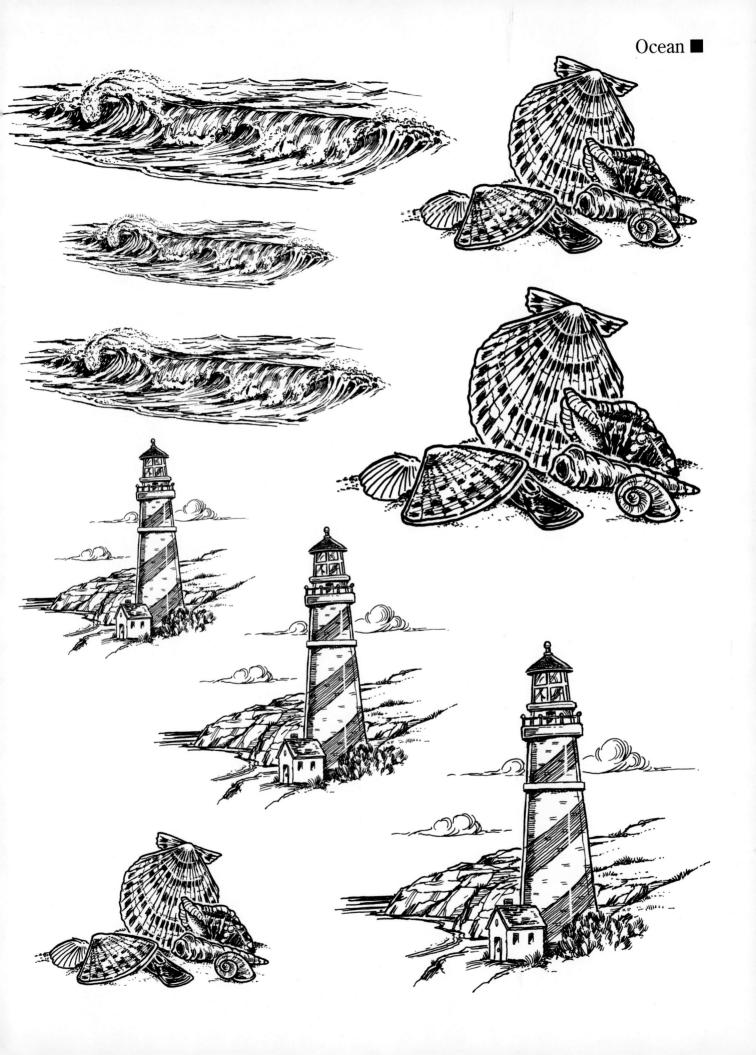

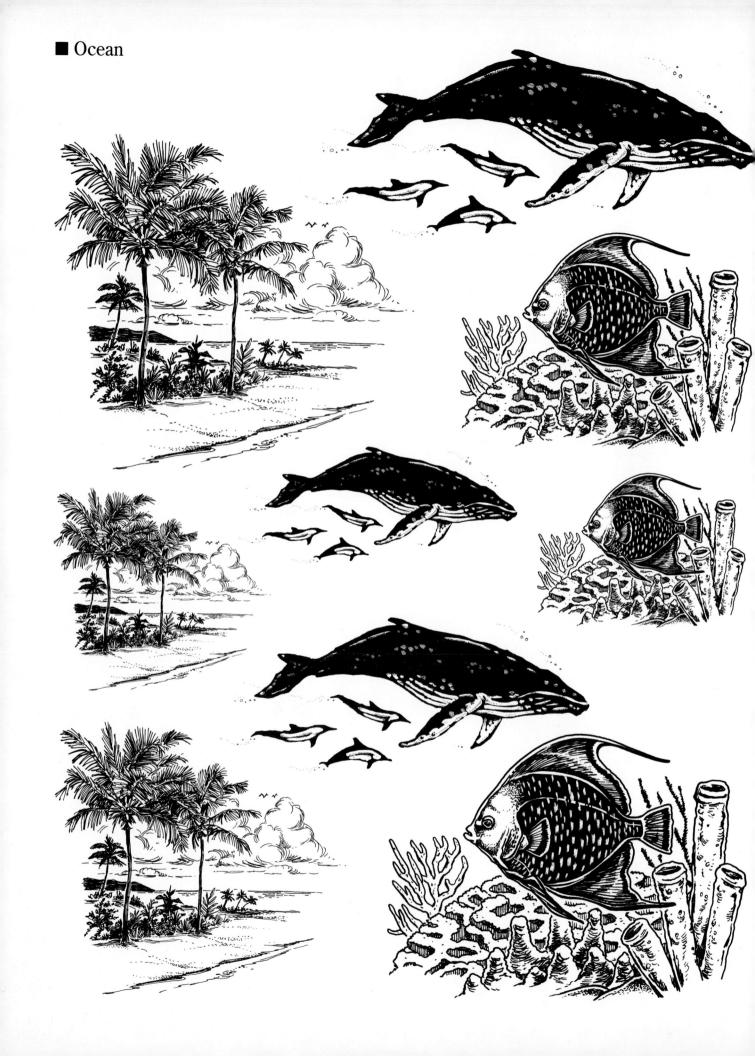

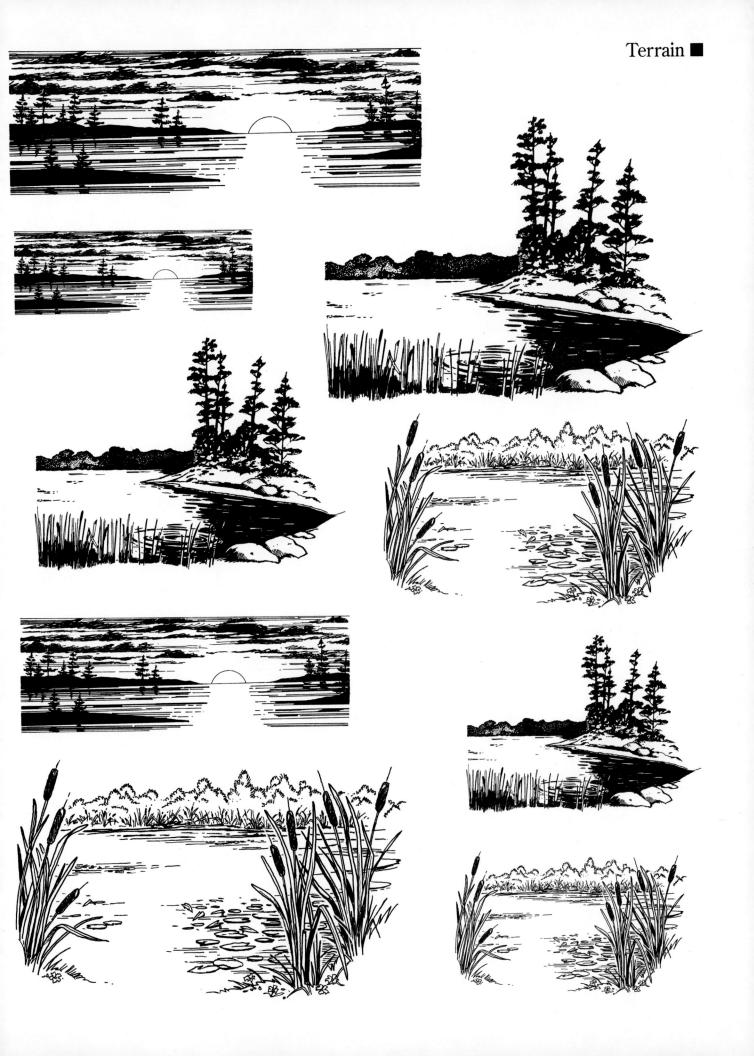

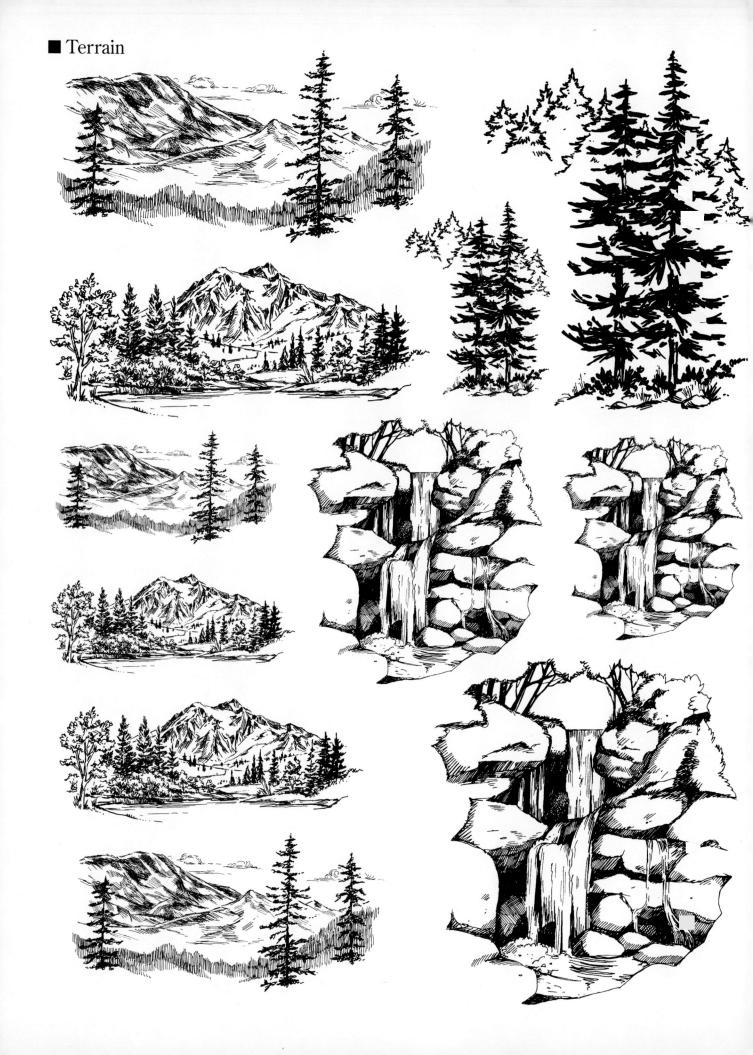

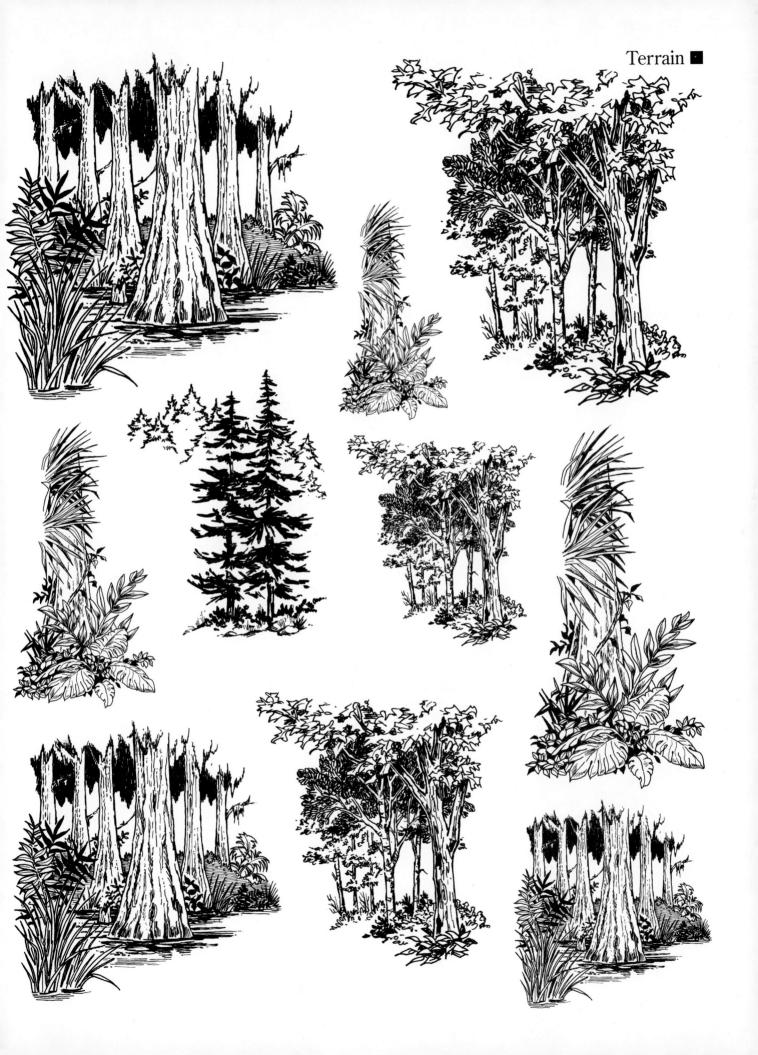

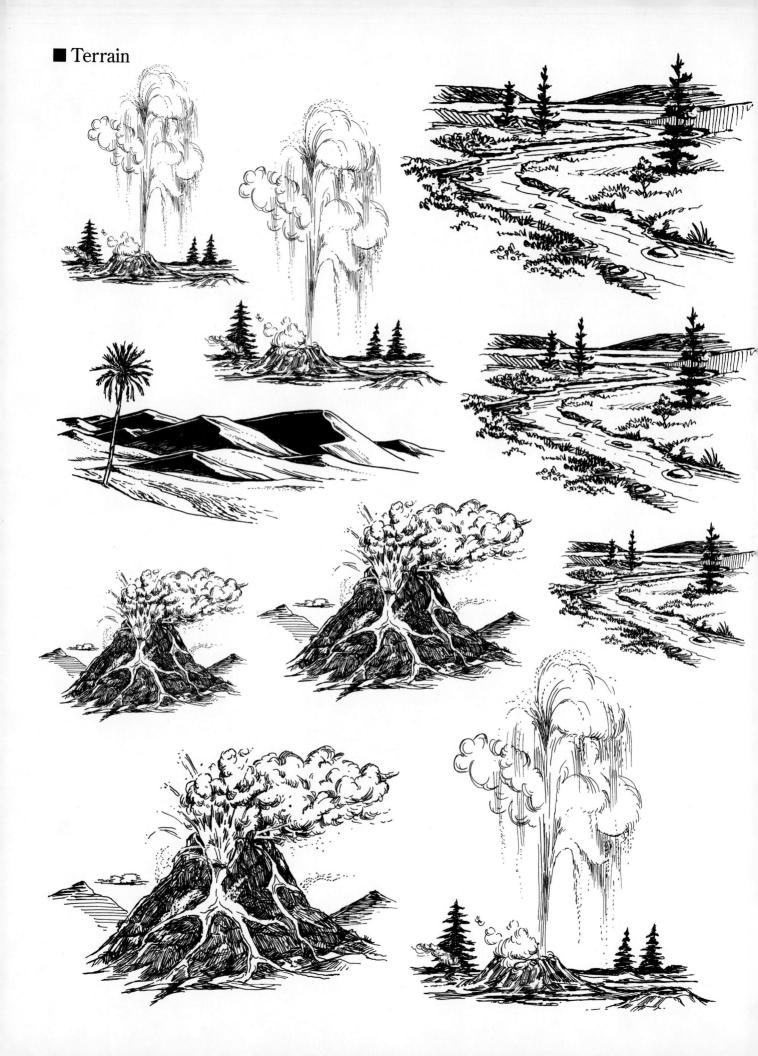

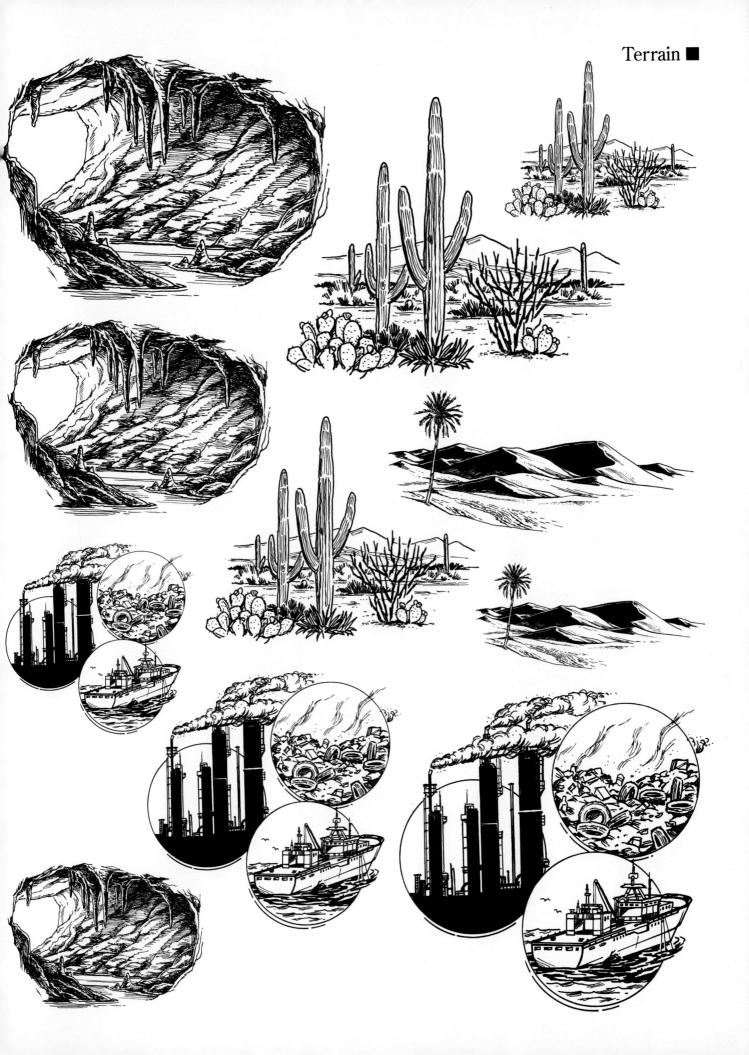

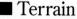